PEN & INK

LINE · TEXTURE · COLOR

BY CARL GLASSFORD

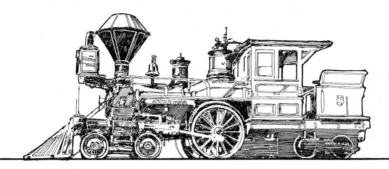

WALTER FOSTER PUBLISHING, INC.
430 West Sixth Street, Tustin, CA 92680-9990
(714) 544-7510 (800) 426-0099 FAX (714) 838-5982

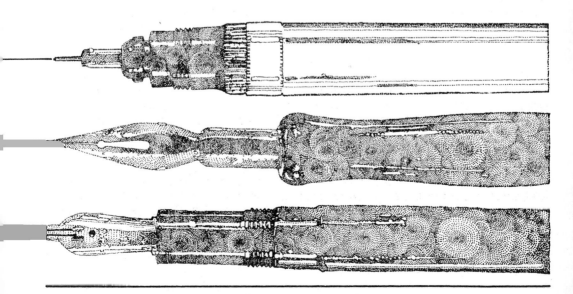

CONTENTS

INTRODUCTION

To be in the visual arts, one must have two great desires. One is to produce art work. The other is to learn. Learning is to improve skills, to expand abilities, to understand hard work, to meet goals, and to enjoy the trip. It begins when we can see, hear, touch, and ask questions. It continues as we remember to ask more questions and apply what we've heard. Learning stops when we lose interest or discipline or motivation. An artist expands from each of his own works and, if he's paying attention, from the work of others around him. I seldom see any art that I don't find something I'd like to try. At a gallery or in a magazine or on a candy wrapper, I see results I will soon test and, if they work for me, add them to my repertoire of techniques. When we tire of learning, we slow, then stop in a race that makes life interesting.

And so this book . . .

Preparing these pages and examples has been a great review for me . . . and I trust some new material for you. I hope I'm not giving away any trade secrets, but I never really understand or properly use any art technique or skill until I spend some time explaining or teaching that subject to others.

To get you into this book, let's get into its author. I began in art by watching others. Mom writing or Dad sawing or Grandad painting. Then I'd try. Art interests were part of growing up, along with baseball, swimming, model airplanes and old cars. Then my interests were far ahead of my abilities, so I took classes. First, there were teachers and instructors who presented the basics. These people did not stifle or discourage me, so I moved on. I quickly added more classes and experiences to develop style and technique and skills. Soon my transcript was full

of boxes with heavy check marks in them. I was passing the right bases. My credentials were being formed and my passport was being stamped. Only a few more semesters and I would move into the "guaranteed happiness" column. Banks were issuing me credit cards and I bought new clothes on credit. It was the American Way. I was about to take my schooling and cash it in on the good life.

The last class, the last certificate, the last party celebrating good fortune came and went. I was no longer a student. I was a professional! Where was my key, my parking space? Who was taking my phone orders and keeping my schedule? My career was here!

Well, reality can be a sudden shock. It really gets your attention just before depression sets in. But, as the lights go out, the real artist wakes up. I soon found that all my training had just prepared me to begin to learn. The classroom continued and narrowed to just me. I was to become my only teacher. I was going to have to push and motivate and seek the next job. Success would be momentary. I was going to sweat through every project, wonder if I would ever be good enough and see flaws in every solution. I would chew my nails and wonder what it would have been like to have become a dentist. In short, I would be in the art business.

The field of visual arts is different from the other creative arts in that a painter or illustrator usually works alone. There is no great audience applauding for a great stroke or a sudden wash. There is no laughter at an area of cross hatching, nor are there tears as a blue and yellow color combination melts into a somber green. There are no snapping fingers, no long lines of admirers, no floral bouquets. The visual arts has an audience of one. The artist must work and finish in an empty theater. There is no feedback outside of his own thoughts. By the time others join to view the work, it's too late. The artist has moved on. His focus has changed and the next project is receiving all of his attention. Even the artist in demonstration seldom exhibits anything he has not long since solved somewhere in the past.

And so this book. I've thoroughly enjoyed the development and use of my pen and ink skills. This kind of drawing is therapy for me. It can be simple studies or complex works of art. I can finish in an hour or spend several days with pen in hand. I can sketch directly on the paper or do elaborate pencil planning and drawing prior to the first ink stroke. Pen and ink drawing taxes skills in drawing, designing, planning and patience. So, we begin . . .

. . . But not at the beginning. I'm going to start at a point beyond a lot of good beginning drawing books found in your library. You have learned basic drawing and perspective and design. You are now ready to work ahead and see how I approach and complete pen and ink subjects. And, should you be a novice, keep the book. You'll pass this way soon enough.

DESIGN

In all the visual arts, design is the foundation of the finished work. The subject may be drawn so realistically that it looks like the work of camera and film. Or it could be so impressionistic that it looks like scrambled photographic chemicals. Whatever the style or execution, design is how the whole is made up of its parts. The positive space of the subject and the negative space surrounding must be considered and used. If you are going to draw an apple, it is not merely the scribing of a circle with a stem on its northern axis. There is the outside shape of the apple. There will be lines or dots that describe the roundness and shininess of the surface. There is the darkness of the shadow and the sparkle of the morning dew. There is the rake of the leaf and the angle of the stem. And what is the mood around the apple? Drawing this fruit is not as easy as it would seem. It is a job of designing an area in which an apple will be displayed in such a state of being as the situation demands. And you thought this was going to be easy.

Within that area for your apple drawing, you will be making a number of artistic decisions. What type of line will you use? You may choose informal and quick sketched strokes for a very casual drawing. Or perhaps you want a detailed and complex illustration full of thin, black lines representing every dot and tittle. Will you stipple the form and the shadows with thousands of dots or let the shape be formed by cross hatching? Should the background be void or solid or textured? Does the composition favor the apple or the apple bowl? What will be the size and the perspective and the contrast? Will this be a single apple or a montage of different apples? All these questions become discussions you have with your imagination and skills. You may make one sketch or fifty doodles before you proceed. Design then, is the result of a process of weighing factors and making decisions, not just the flash of a light bulb. I don't rule out inspiration or impulse or intuition, but I do say none of those flashes of talent or brilliance ever happens without planning and preparation. You can't splash, pour or douse anything out of an empty bucket.

Pen and ink drawing is not the ultimate art. It is one of many ways of visual expression. It has limitations and boundaries. It also has unique attributes found only with the ink line or the pen point. Rather than try to line up and list the pros and cons of pen and ink drawing, let me make notes and comments on each example. Therefore, the worth of this book will be all 64 pages, not just a few highlights here or there.

MATERIALS

Pen and ink drawing obviously requires some kind of pen and the use of a free-flowing ink on some drawing surface. That may be an oversimplification, but with the variety of art materials available today, it's not always easy to select your materials. Years ago it would have been a crow quill pen, a bottle of india ink and a rag paper. Now it's mechanical drawing pens with a number of different point sizes. You could use felt tipped pens that offer several choices of nibs and ink colors. You can draw on hot press board or textured acetate. The variety of instruments you can put in your hand to make lines on all sorts of surfaces causes me to encourage you to go through all the supplies and let you choose your own pen and ink and paper. As you browse through your local art supply store, keep in mind that even as you buy today, new products and techniques will be on the market tomorrow. You may end up with a bamboo tip on rice paper. Say, isn't this where I came in?

I will describe what I have used in this book and what I find successful 95% of the time. I start with mechanical drawing pens. I have a set with many interchangeable points, but I use a #00 most of the time. With the lines and dots I use in my drawings combined with the size of my hand and a comfortable hand stroke, the #00 pen fits my style of drawing. I do keep a #01 pen inked up for outlining and black fill-in work. I find I use the other sizes so rarely that the ink dries in the mechanism before I use it again, so they sit in the holder dry and clean and waiting. And speaking of clean pens, I wash out my points every time I fill the ink reservoir. Mechanical pens are not temperamental, but they do like to be cleaned with warm water just before adding fresh ink.

Another SOP for me is to have a supply of animator's white cotton gloves for my drawing hand. Some surfaces are so sensitive to the oil from the skin that a touch here equals a bleeding there. And when you don't want a fuzzy line in the middle of a complicated drawing, you'll want the drawing gloves. I always cut the thumb and first two fingers off at the halfway on each white tube. This puts cotton on that part of the hand that has to touch the drawing surface but leaves the fingers open and free for an accurate drawing feel or sensation. Be prepared for onlookers to inquire as to the nature of you injury or if you have a burn. But, it's worth your necessary explanations to protect several hours of art work. To buy your gloves, you may have to order through a large material supply house, for they are not a common shelf item. But make the effort, and change them from time to time. An obviously soiled glove can become an unwanted rubber stamp or footprint of frustration!

As for other types of pens, I do use a split metal point sketching pen on occasion . . . when I'm looking for new drawing styles of a different approach. But, I usually go back to the familiarity of the mechanical drawing pen . . . art has a lot to do with familiarity and comfort zones. For lettering and decorating, I have a set of calligraphy pens. Their broad points and wide strokes always give me a feeling of connection with some very ancient artists. Good for the roots as well as the design.

And, to finish with pens, I have a variety of broad and fine point colored felt-tip pens for renderings, layouts and embellishments. There are a lot of brand names and price tags on the felt tips. Experience, again, will help you make your long term purchases. I have found that the cheaper pens don't really give you good service, so spend a bit more and get better results.

Ink is another material of many choices. I use a permanent all-surface india ink that is classified as super black. It flows through the pen with minimal clogging and gives a very black, opaque line. I avoid any black ink that is water soluble, for they can and do smear at all the wrong times!

Now, to enter the world of colored inks. Because of their make-up, these inks are really dyes or highly concentrated water colors. Although very intense or brilliant as they come from the bottle, they are translucent and readily thinned with water, making art washes, dulled or faded colors, and clean-up very easy. For drawings to be reproduced, they are wonderful, as they give a good account of themselves during the printing process. However, for art to be used in long term display, I use regular water colors from tubes to paint and wash into my drawings. Colored inks fade much faster than water colors.

I almost never deliver color to a drawing with a pen. It is always a thin, sable haired brush. I use a #1, #2 and #3 a lot. Thinner brushes don't carry enough ink and thicker brushes are useful only in washes. But, here again, you will have to do some testing to find your likes and uses.

And while I'm on the subject of color, let me again be a generalist. The colored inks and dyes I use have brand names or general art classifications like Burnt Umber, Ultramarine Blue or Tangerine. But, I use dyes with varying degrees of water, and seldom get a true out-of-bottle color. So, I will refer to the colors in my ink drawings as red, light blue, flesh light and dark, brown, etc. As you apply your color, it will always vary with the water versus ink versus surface versus size of area. So, let us get used to simple terms rather than what may be printed on tubes or bottles.

Finally, the drawing surface. I use a cold press illustration board for pen and ink alone or with colored inks added. I use a hot press illustration board for pencil drawings. I avoid a real white, white surface for the simple reason that I liked duller white looking back at me. I also avoid surfaces that are so hard that ink sits on top rather than sinks in a bit. These are the surfaces designed for mechanical or technical drawings. Again, they are out of my comfort zone, so it's only personal preference. If I'm only using india ink and want to use a paper I will draw on a 400 pound plus rag drawing paper. I like the feel and result for ink, but will not put colored inks and washes on these drawings because the paper will warp and bend. The more liquid, the stiffer the surface.

Well, these are some preliminary thoughts and suggestions. As we go through the next pages and examples, I will add some comments on line, technique and color. Remember that I am only showing you what I have found to work for me. You will find some of this immediately useful and some of this only a starting point to finding your own styles and techniques. That's the beauty of art and the study of visual interpretation. You are the sum of all you've been exposed to , but only the start of all you will produce. You learn with each piece or study or rendering. You are ultimately your own best teacher, worst critic, and self-starter. Motivation isn't really the acclaim or money or attention. It is the thrill, the pain, and the learning you do all alone as you work to make lasting results.

If you need to perform for a crowd, put this book back on the rack and go practice the piano.

LINES AND DOTS AND COLOR

In pen and ink drawing, all you really have to work with is lines and dots. You can vary the length and the width and the size, but there it is—a serious limitation! No various degrees of shading. No dilutions with thinner or water. No brush stroke or knife scrape. Just lines (or very short lines I call dots)! Well, here's where we get creative to see how those lines can become art.

First, let me show some examples of texture. Here are some arrangements of lines and dots that will be background or shadows or filler material.

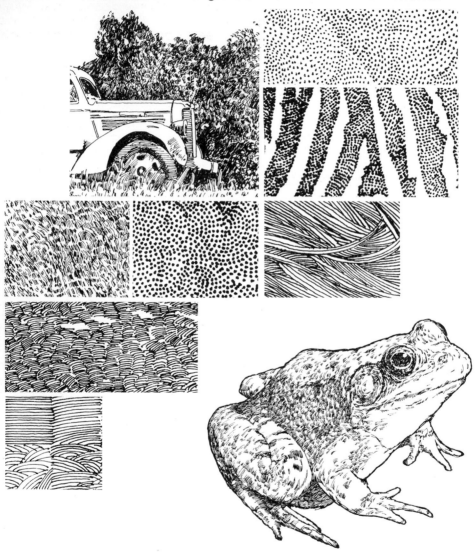

As you study and try these examples, you will be aware of two things. First, none of these little squares make any sense unless you are an ink salesman. These examples have to be incorporated in the forms of a drawing before they begin to be a part of art. Stay tuned and watch for them to appear in upcoming examples. This is like the glossary review before the hands-on lab work.

Secondly, you may recall my previous use of the word "patience." My family often wonders what I do as I sit at my drawing table for hours with my nose and pen point at the same location. The only movement is a slight tattooing motion of my drawing instrument. Welcome to the joy and patience of stippling. I often think of the men in Europe who lay the cobblestones. They sit on short stools near a pile of square stones and gently tap each cube into a layer of level sand. Each man has his own unique pattern of placement—almost a fingerprint—in his working area. To me, each dot is a stone and I'm filling a plaza or surfacing a street. It often takes a lot of games or variations to maintan patience and finish a drawing. I often leave the fill-in to last, or at least until the design has been set. Try not to mix the anxiousness of creativity with the busyness of completion. I do this "busy" work with my favorite music playing in the background for entertainment and cadence. When, at some future time I again see a particular drawing or design, certain strains of music seem to flow through my vision.

Color and line drawings never joined during my schooling. Pen and ink was just black and white with an occasional nod to gray. I'm certainly not original, but I wanted more for drawings than colorful mats and frames. At first, I would put a colored wash behind the subject to make it stand away from the background. Then I washed light color on the subject to define form and shape. And, finally, I used various bright colored inks to color between the lines. Oh, horrors! Paint by numbers. But it worked and I liked it. I even got an air brush set-up to add more color. I will again defer the later pages for examples of the use of color, but it certainly adds to my enjoyment of the work.

LINE DRAWING EXERCISE

These two glasses were sitting outside in strong, natural lighting. I looked at them as they appeared in three dimensional form and went through the process of re-creating their image as ink lines on a two dimensional surface. This interpretation requires the artist to take what he sees and use lines to make a drawing to signal in others a recall pattern that equals two glasses. Each artist has a drawing style that varies as widely as our handwriting. There are, of course, visual cues each artist must use to show the two glasses. Here is my version of what I saw with as little detail as I can use to convince you that you're seeing two glasses.

But, the artist doesn't stop there. The next version of the two glasses have been embellished. I've used several styles to show that even the same artist can approach or render a drawing with different techniques. Note the stems of each glass and see the use of lines or dots to work the drawing. I usually use the same approach for the entire drawing—foreground, middleground and background—but here are some choices in line, composition and design.

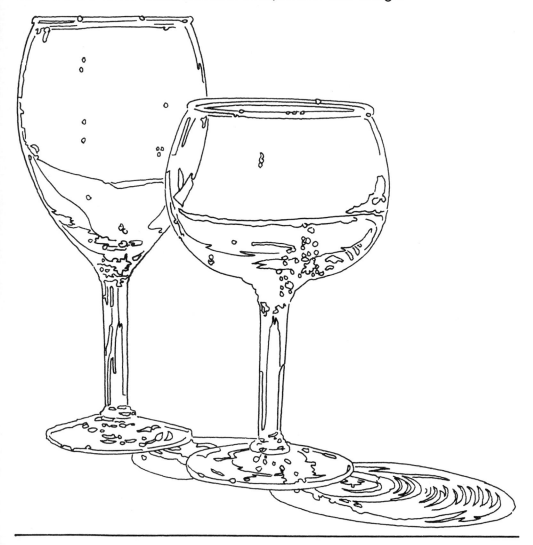

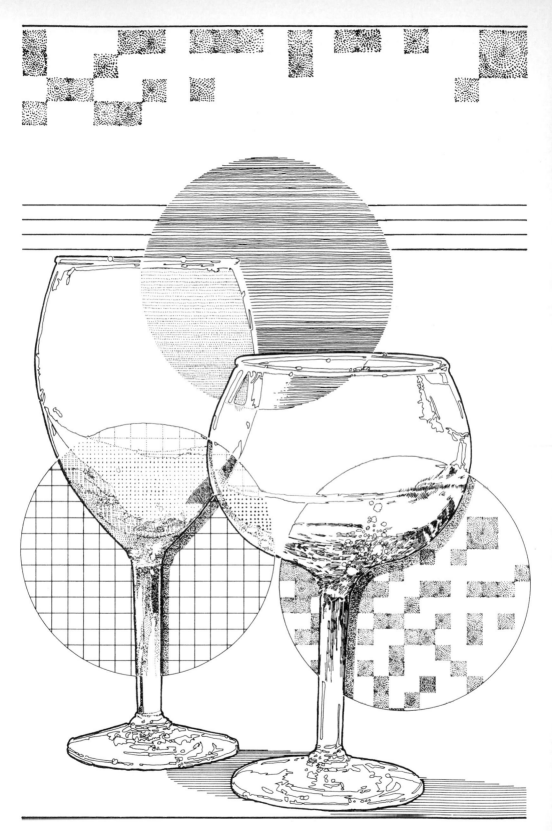

DRAWING THE FACE

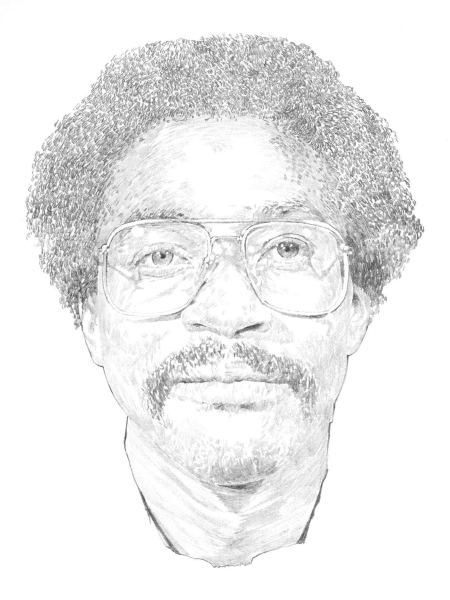

Here is the first example of the use of pencil to help the completion of a pen and ink drawing. I show you only the finished, highly detailed pencil study to illustrate how I've worked the hair and face and glasses into all the shapes and shadows I can see. Not shown are the preliminary drawings with construction lines and mistakes. But, I want you to know that I really "learned" this face before I went into the pen and ink techniques for the second drawing.

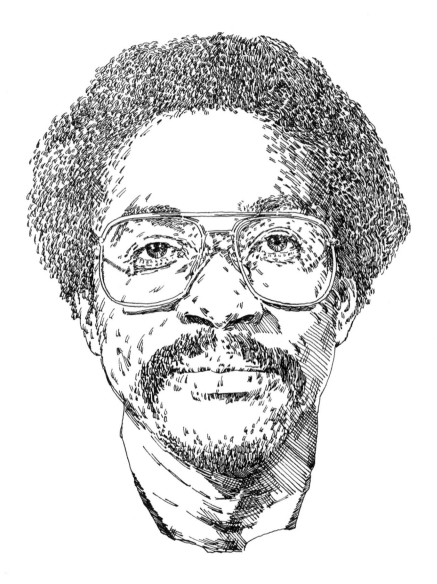

Besides the use of line and shadow for details, note the visual cues I used to convince you this was a particular person. He's black, so I must emphasize facial characteristics rather than just ink the skin solid. I used the glasses and mustache to show roundness. I spent a lot of time in the hair to make the drawing more convincing. As a matter of rule, I spend the most time on faces doing hair—not that hair is so important, but that it frames the face and character. It takes very few lines to draw the face, but much more thought and control to do it right.

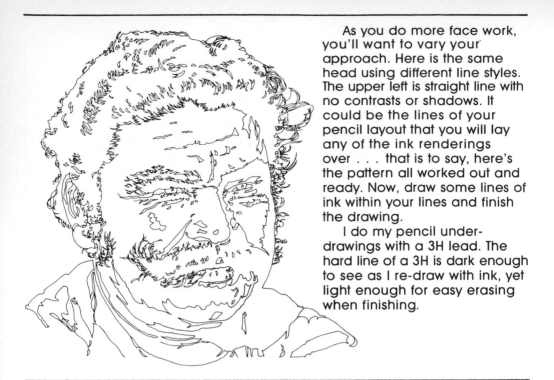

As you do more face work, you'll want to vary your approach. Here is the same head using different line styles. The upper left is straight line with no contrasts or shadows. It could be the lines of your pencil layout that you will lay any of the ink renderings over . . . that is to say, here's the pattern all worked out and ready. Now, draw some lines of ink within your lines and finish the drawing.

I do my pencil under-drawings with a 3H lead. The hard line of a 3H is dark enough to see as I re-draw with ink, yet light enough for easy erasing when finishing.

Be aware that many of the drawings in this book are reduced from actual drawing size, so I put small areas of actual size reproductions so you can see actual line and point—otherwise, you would take me literally and try to draw under a microscope.

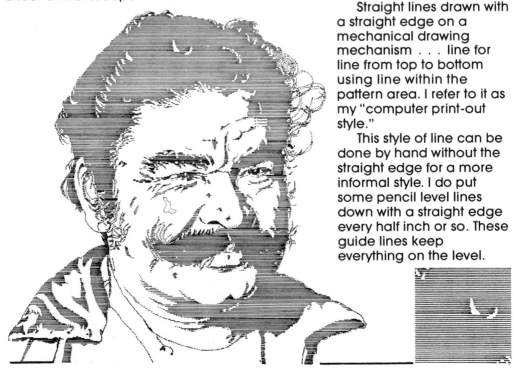

Straight lines drawn with a straight edge on a mechanical drawing mechanism . . . line for line from top to bottom using line within the pattern area. I refer to it as my "computer print-out style."

This style of line can be done by hand without the straight edge for a more informal style. I do put some pencil level lines down with a straight edge every half inch or so. These guide lines keep everything on the level.

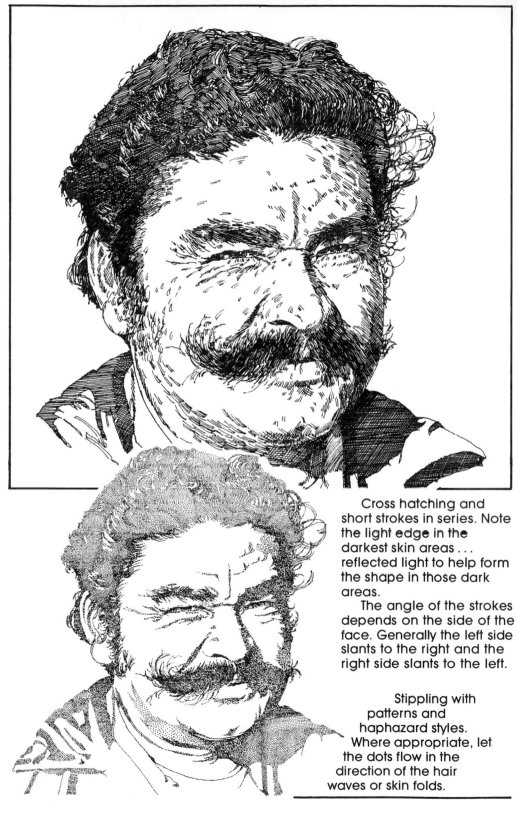

Cross hatching and short strokes in series. Note the light edge in the darkest skin areas ... reflected light to help form the shape in those dark areas.

The angle of the strokes depends on the side of the face. Generally the left side slants to the right and the right side slants to the left.

Stippling with patterns and haphazard styles. Where appropriate, let the dots flow in the direction of the hair waves or skin folds.

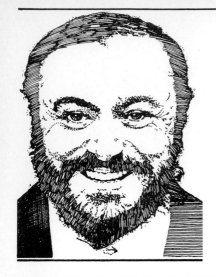

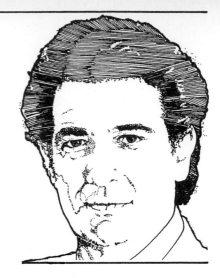

MORE FACES

The face is the same items all different. Two eyes, a nose and mouth with some hair has infinite variations. The artist "picks on" those lines that makes a face individual. Start with the eyes and their surroundings. It's the corners that set the personality. Next the mouth and teeth. Look at the upper lip and triangles at each end to match your subject. The rest will fall into place. Hair, warts, glasses, noses, ears all help define the face, but it's those corners that make personality and recognition. Remember to put a white spot in the eye. It is always there (baring heavy shadow) as reflection. It also adds a glint of character. Be kind, as you draw, to leave out some wrinkles or to stretch a chin line. My subjects always look ten pounds or so lighter!

This drawing of artist William Alexander is, perhaps, my most often reproduced work. Originally used as a cover for a book from a public television series on painting, it is now a logo for hundreds of products. I enjoy seeing it everywhere, for it reminds me of the success I had in capturing the very warmth and personality of such a nice man.

Note the lined background or use of negative space to frame and set off the face.

William Alexander drawing by permission of the KOCE-TV Foundation.

Drawing women is more than just adding hair. They have a softness that means less lines and shadows. They tilt their heads. They use their faces for more emotion than men. They are just part two of drawing faces . . . not that there's any ranking, I just find I treat their construction and drawing with two separate approaches.

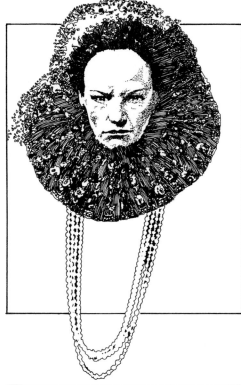

Drawing children is the third approach. Often, there are no lines to define the face or hair. Then I rely on animation or background to help complete the drawing. Arms swinging on a rocking horse may do the trick. New born babies are impossible!

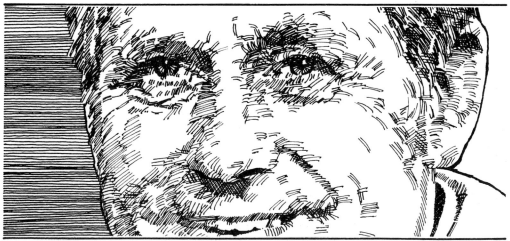

DRAWING ANIMALS

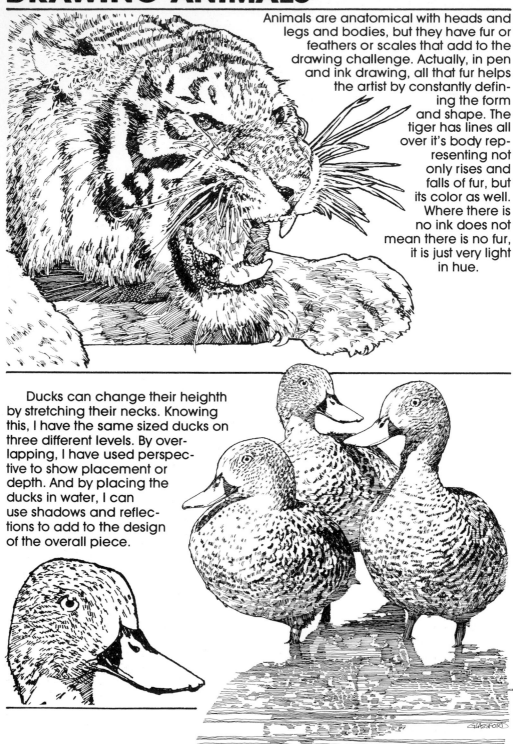

Animals are anatomical with heads and legs and bodies, but they have fur or feathers or scales that add to the drawing challenge. Actually, in pen and ink drawing, all that fur helps the artist by constantly defining the form and shape. The tiger has lines all over it's body representing not only rises and falls of fur, but its color as well. Where there is no ink does not mean there is no fur, it is just very light in hue.

Ducks can change their heighth by stretching their necks. Knowing this, I have the same sized ducks on three different levels. By overlapping, I have used perspective to show placement or depth. And by placing the ducks in water, I can use shadows and reflections to add to the design of the overall piece.

GLASSFORD

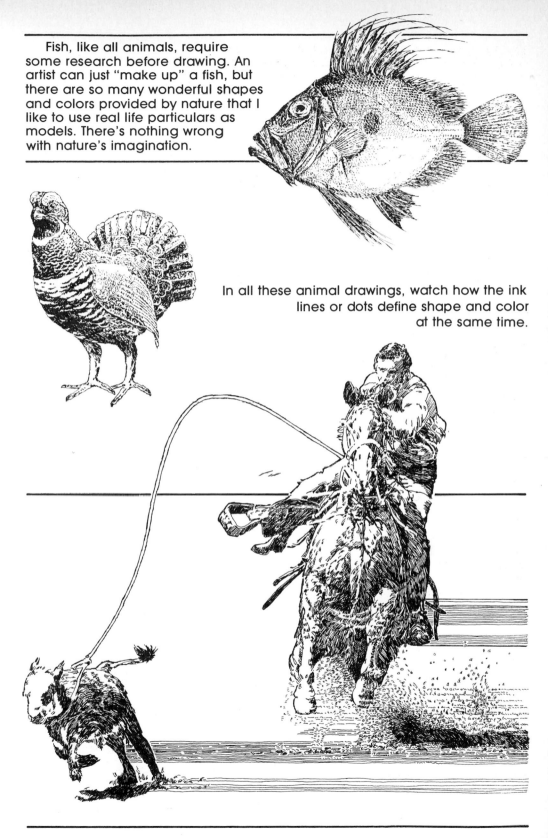

Fish, like all animals, require some research before drawing. An artist can just "make up" a fish, but there are so many wonderful shapes and colors provided by nature that I like to use real life particulars as models. There's nothing wrong with nature's imagination.

In all these animal drawings, watch how the ink lines or dots define shape and color at the same time.

THE QUAIL

Quails and hawks are my favorite birds to draw. Their natural needs for camouflage and beauty give the artist a lot of wonderful lines to work with. This bird, in full color, is magnificent. But, even with black lines, the patterns and shapes are challenging. Look how the feathers form natural contour lines to shape the chest and wings and tail.

As we go into animals, you can see you must do two things in order to enhance your drawing skills. One is to move next to a zoo. The other is to collect picture books about animals for your library. The range and ability of any artist can be judged by the size of his library and/or travel tickets.

I would recommend that you not only have a library of books, but that you collect samples in a filing system. From magazines or newspapers or where ever, cut out photos and illustrations and file them where you can later find them. Your system could be very simple and under "A" you have a folder on "Animals." Or, you may be collecting a large reference file with many divisions and subdivisions. The important thing is to use what you collect. If I have to draw an elephant, my file shows African or Indian, male or female, young or old. If I don't have an item in my collection, I do some library work, then add what I find for some specific assignment. I review my files regularly to refile or discard or rediscover. The time I put into maintaining my reference material saves me a lot of frustration as I start future projects.

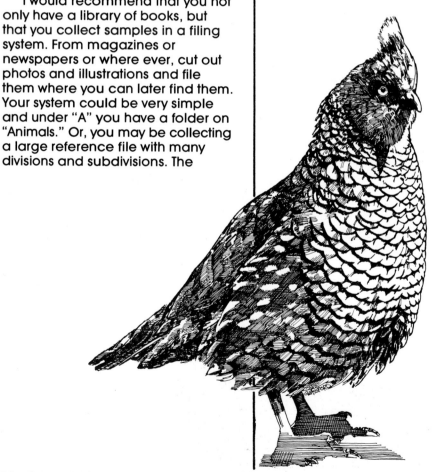

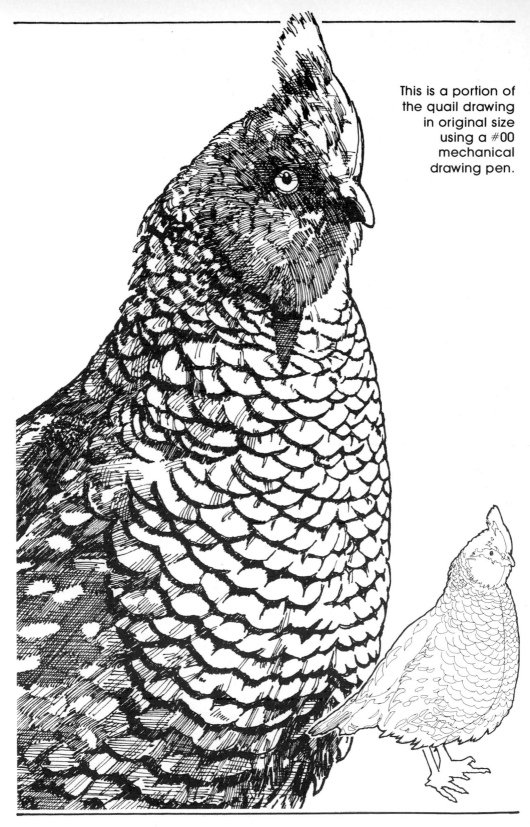

This is a portion of the quail drawing in original size using a #00 mechanical drawing pen.

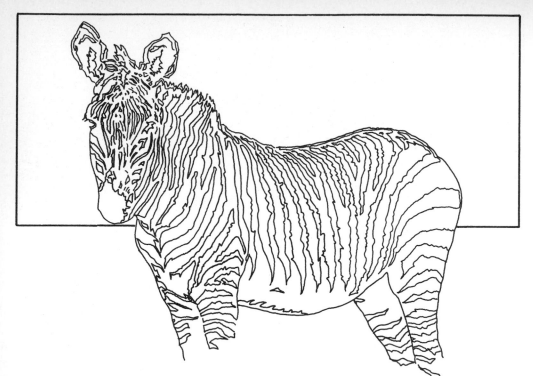

THE ZEBRA

This animal is nature's challenge to artists. As Beethoven and Mozart wrote music that was so complicated lesser musicians couldn't play it, so nature made zebras. It's even more of a test when you realize it's *only* black and white! And where on the African plains is there any other black and white?

Since I have had many assign-ments drawing "exotic" animals, I decided to take my research in hand and visit the San Diego Wildlife Park for a photo session. Pictures of such a collection of animals and birds would help my reference files for anatomical and coloring aids. As it turned out, I went to the park twice . . . once with my kids and once without. They were very nervous around animals and very interested in all the food concessions available. Therefore, consider your photo reconnaissance by yourself or with others who are very interested in your subject.

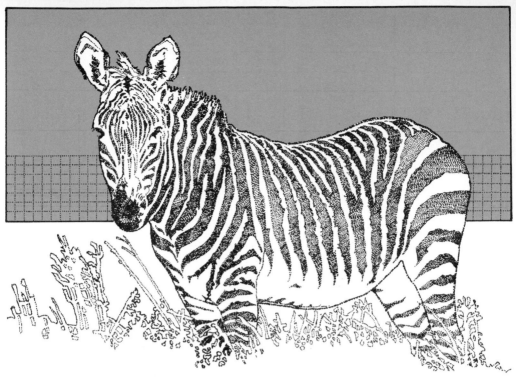

The zebra starts out somewhere between a horse and a donkey. His nose is black and you're on your own from there. He's a white animal with some black camouflage lines running somewhat symetrical to his body. He seems to be the same pattern on both sides, but don't count on it. From photographs, I put together this assemblage of stripes, but don't quote me. To save myself from drawing feet (or hooves), I've put the animal in tall, designer grass. The background pattern is optional.

Another point to make about animals with distinctive patterns: no two zebras or giraffes or tigers are alike. It's the old fingerprint approach Mother Nature has taken. I don't know how helpful this information will be to you, however, for once one draws one zebra, the second is seldom attempted in the same time period?

The final point on decorative animal drawing is to avoid drawing shadows or mud stains or other marks on the body. The shading will interfere with the animal pattern, so always draw them on overcast days.

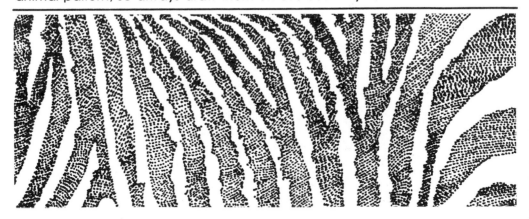

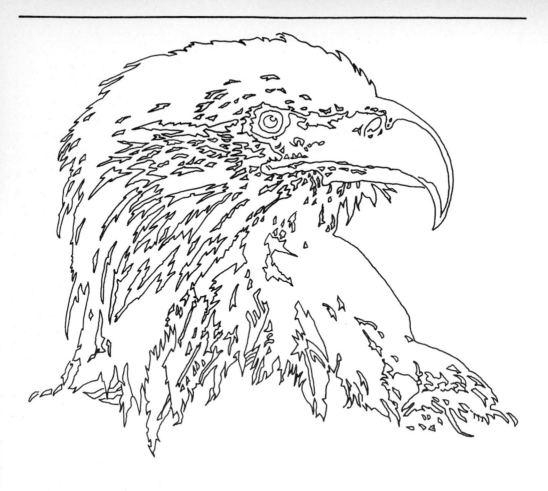

THE EAGLE HEAD

The line drawing in the upper left is really the end of the pencil contruction work. The head is formed, the eye is placed, the beak is curved and the shadows are located. Now, as I am using the stipple technique here, I begin to put in the dots. Some dots form lines to follow the form and function of the beak and eye. Other dots form the flow of shadows in and out of feathers. Finally, I go around the outline of the head with heavier dots to make a strong outline to separate foreground from background. With dark, medium and light at pattern areas, the head is completed.

The question of choice between short line technique versus the stippling approach is a matter of what will work best with the subject. In the case of this eagle head, the dark areas of the white feathered head are not very dark. The dots forming the shadow areas are less ink than the short line technique. With less ink forming the same shape, the "dark" isn't so dark and you get light gray instead of black. Dots or stippling allow you to turn down the contrast by using finger dots or greater distance between the ink.

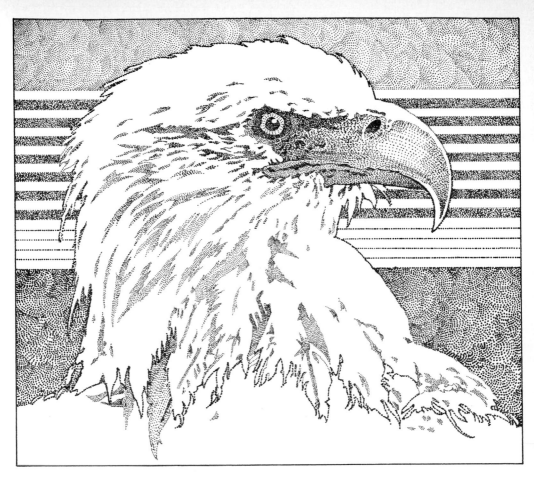

The background is a matter of design and time left to complete the drawing. I used a dot swirl pattern with two different pen points.

The drawing below is enlarged to illustrate how the dots in the stipple technique come together to form objects or spread out to become light or dark textures. If your area is to darken, use more dots or bigger pen points. Let the dots follow the natural lines of the body. You can draw with a line of dots the same way you can draw with a solid line, it just takes longer to make the dots.

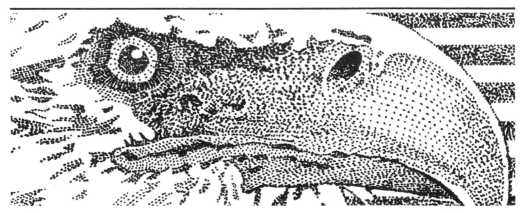

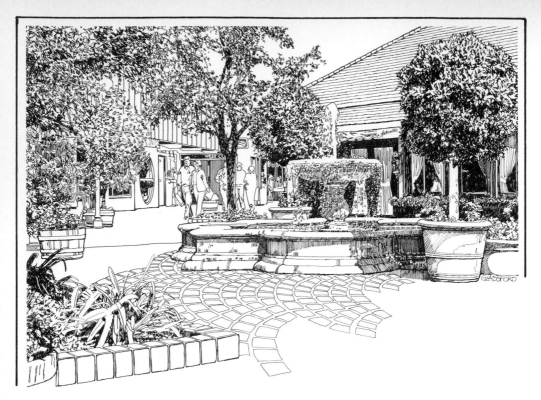

DRAWING BUILDINGS AND PLACES

Without some perspective drawing and mechanical skills, drawing buildings and their surroundings will be difficult for all but the very impressionistic artist. Planes, surfaces and relationships all work together to form the rendering. You will be drawing cubes and cones and pyramids and cylinders with some form of surface texture treatment. Whether you're drawing in a loose free hand sketch or a tight, straight edge format, how you place the components and decorations will determine the result. For some great examples, pay attention to real estate ads in newspapers and magazines. You can not only learn a lot about drawing structures, but how to treat trees, bushes, people, cars, clouds, etc.

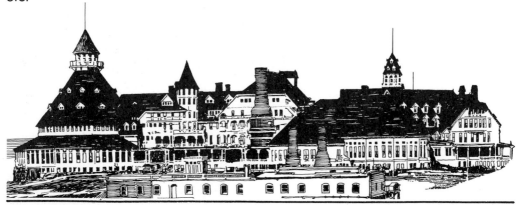

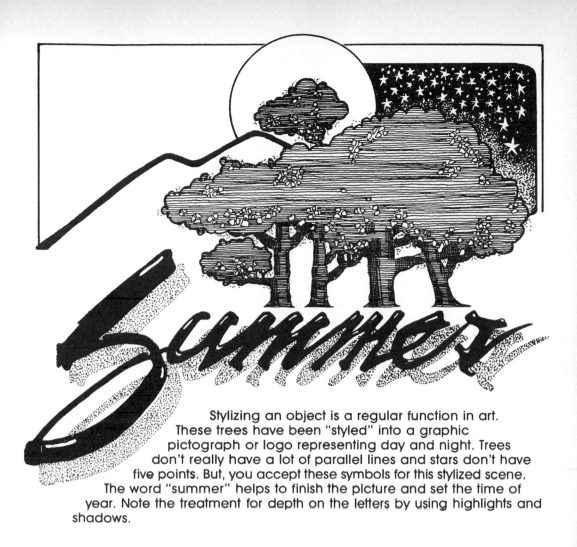

Stylizing an object is a regular function in art. These trees have been "styled" into a graphic pictograph or logo representing day and night. Trees don't really have a lot of parallel lines and stars don't have five points. But, you accept these symbols for this stylized scene. The word "summer" helps to finish the picture and set the time of year. Note the treatment for depth on the letters by using highlights and shadows.

These bottom drawings are of the old Coronado Hotel in San Diego. They are from photographs taken shortly after the complex was completed. There is a real charm in drawing old buildings. There is so much more character than the glass and steel of today.

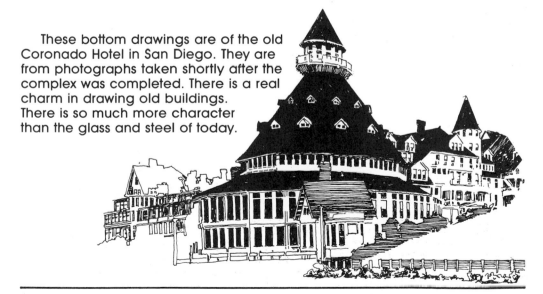

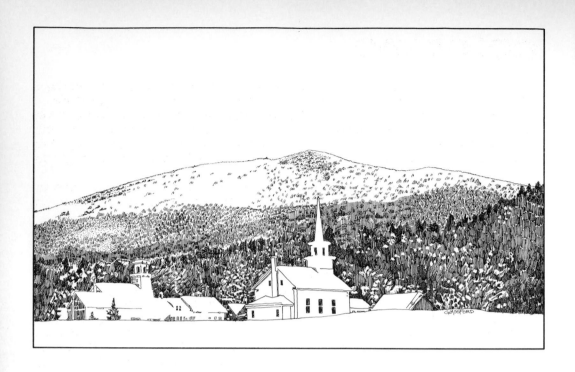

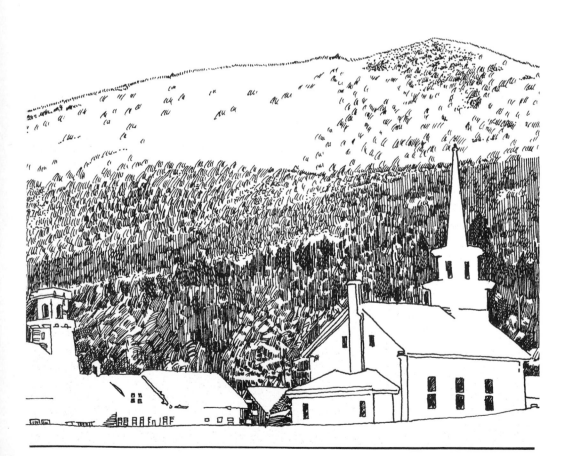

COLORADO

Here is the first example of a complete picture using pen and ink to create a wall hanging that is a work of art. As with the zebra, we're only dealing with black and white, so the illustration is winter. Look how the concentration of lines form the trees and brush. As the eye travels further into the distance or into the snow, the amount of ink lessens to little or none. Notice too, that near the darkest (in this case the top of the near tree line) there is a white glow or highlight to separate the background.

As you do these kinds of scenic pen and ink drawings, remember to keep your detail work in the foreground or middleground. Anything in the distance can be represented by values of gray rather than any details or shapes.

Before you begin to ink a scene, check your pencil work for content, design and placement. Then, on a separate paper, practice the strokes you intend to use for trees or buildings or whatever. These off board studies will teach you how to proceed or help you avoid lines you don't want. Incorporate your successful studies and improve your not-so-goods.

One other "trick" I use is to draw my scene on a very small scale . . . a thumb-nail sketch. It's small enough to manage under the movement of my hand and wrist. With this control, I can get the total drawing composed and organized. Then I project my final thumb-nail onto a larger surface and trace with a 3H pencil. I add the pencil details not drawn in the small sketch, then begin the inking. Whatever 3H pencil lines left on the drawing are easily erased.

BIG CITY SKYLINE

This is another stylized rendering. Tall buildings at night are beautiful displays of lights and darks. There are three things I want to show here. Structured and unstructured window patterns, the lines rising to black sky to indicate street illumination, and the white line halo around the building outlines to separate them from the background.

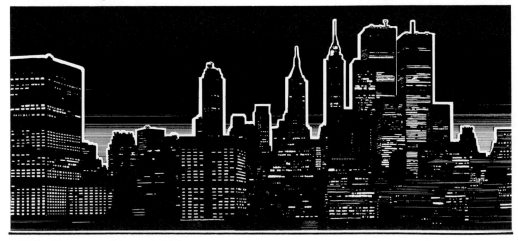

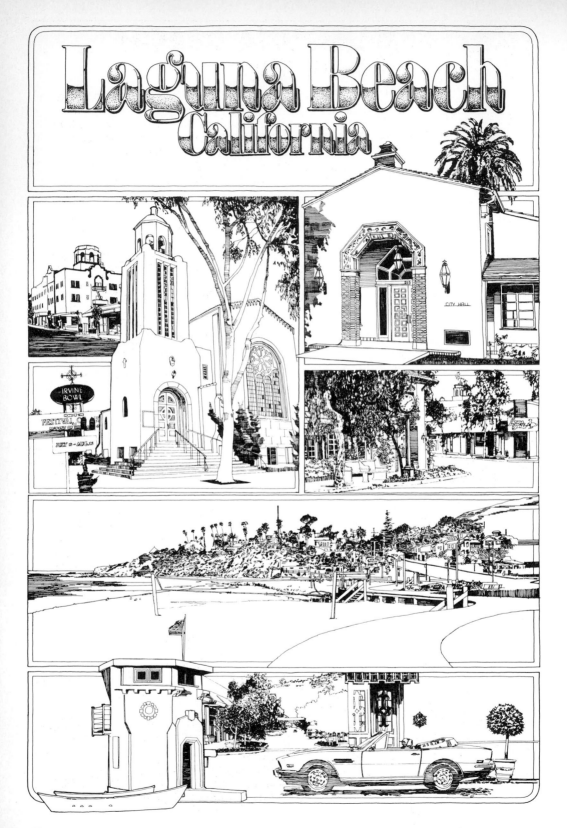

LAGUNA BEACH POSTER

My home town has been featured in many a poster or drawing. This is a version I did a few years ago. I picked places that I thought important as a resident, not as a tourist. I also didn't put any people in the drawing, as my favorite memories of Laguna are the days in the winter when the residents have the town to themselves.

I also picked older structures to illustrate. This sort of project requires some history, not hype. There is a difference between atmosphere and real estate investment.

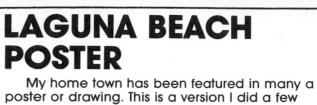

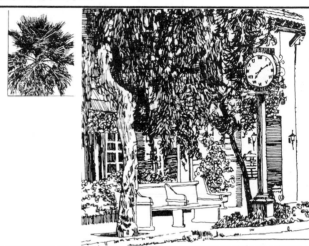

Part of the challenge of a montage is how to put the elements together . . . where to stop drawing and start the next. Sometimes there's a natural break and sometimes you have to create the break. Here, I've used white line borders that hold several drawings in one illustration. Notice, even the borders can be started or stopped to form the design.

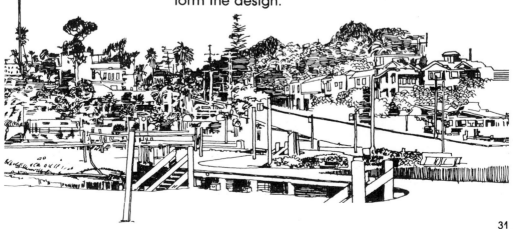

DRAWING DESIGNS

Here is a drawing of an idea or a concept or a symbol. It could be a trademark or logo representing a product or an event. It could be an original design for the purpose of decoration. Whatever it is, you use line art to create an image of someone's imagination. So here are pen and ink techniques rendering an abstract circle and a real pencil into a representational design.

DRAWING THINGS

The category "things" is rather large . . . it includes everything! In this case, I mean product drawings. As a commercial artist, I draw what the client wants to sell or promote. Sometimes, the client gives me a free run of imagination to illustrate his concept. But usually, he wants a specific product to put in the customer's eye . . . a car, a purse, a bottle or building. Now the artist has an object to illustrate in an advantageous manner . . . make it look good.

Here are some examples of machines using line to form detail or perspective or movement. It is a challenge to be creative between two hub caps.

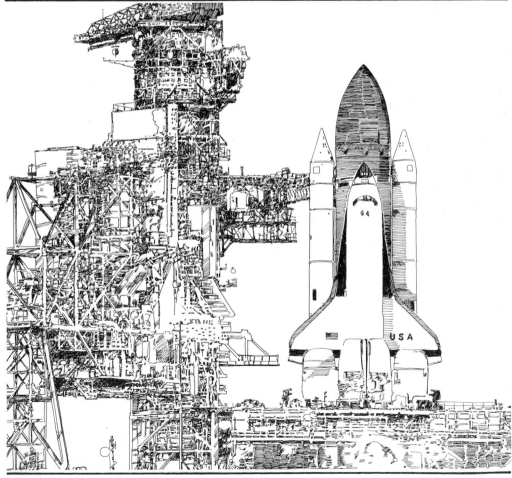

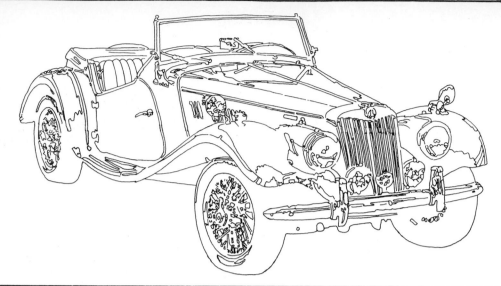

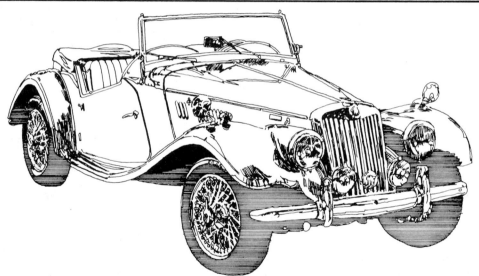

Here are four cars in the product illustration category. The upper left is an old MG sports car. The first drawing would be the finished pencil (3H type) drawing waiting for ink. The second is the final rendering with shadows, reflections and details. In this case, I've combined the under carriage shadows and black tires into continuous ruled lines. It's a useful technique when dark areas melt into each other.

The top right drawing is a simple line outline with no detail, but a lot of texture in the wheels and shadow . . . once again blending darks. I like how shadows put the object on a flat surface or plane.

The little racer has lines that indicate speed or motion. Once I drew the pencil work-up, I put a push-pin in my drawing table about 18 to 20 inches to the upper right. Then I put a straight edge to the pin and swiveled from fin and helmet to tire and shadow, drawing my straight lines to form all the dark values in the drawing.

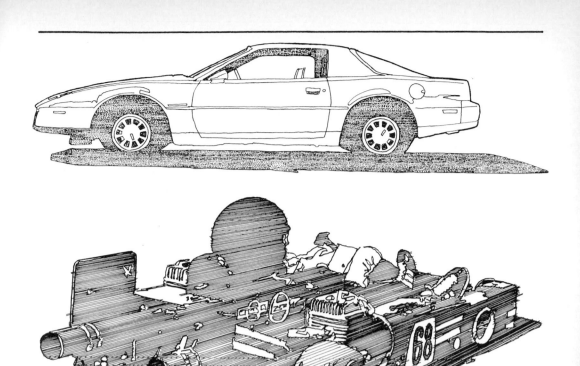

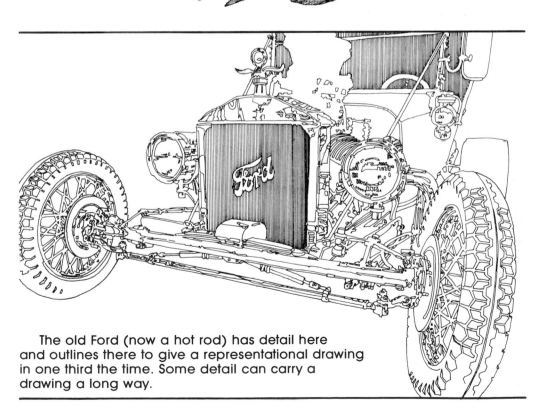

The old Ford (now a hot rod) has detail here
and outlines there to give a representational drawing
in one third the time. Some detail can carry a
drawing a long way.

'31 CHEVY

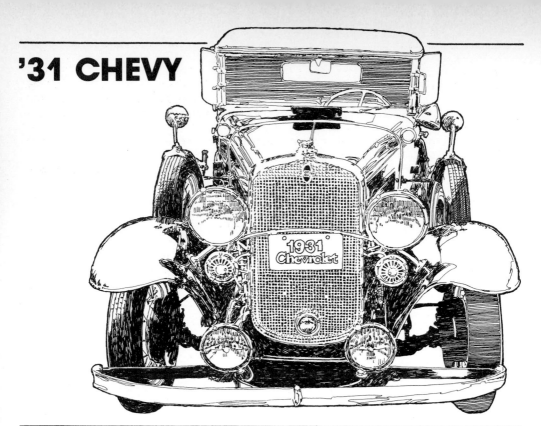

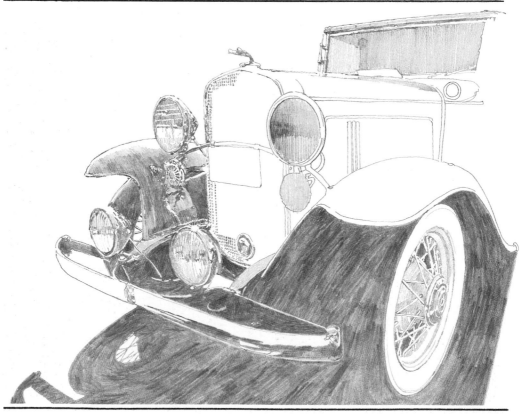

Here is a work that is from my photo file. Wherever I go I usually have a camera with me to photograph subjects for future drawings. Trees, old buildings, animals and especially automobiles have become quite a collection for research material. I will often have a need for general background fillers and my photo file will offer the right barn or bush or backdrop. But, my car collection frequently becomes the main show. I enjoy rallies and displays and shoot pictures from all angles to be models for future drawings.

This '31 Chevrolet was sitting in the late afternoon sun and the shadow was almost as interesting as the automobile. To get the shadows and details organized before I inked the drawing, I did this study with an HB pencil. I concentrated on the front lights and bumper and how they tied in with the shadow and wheels. Once I "understood" how things flowed together, I went to the ink rendering. I put a light brown or sepia wash on the bodywork—and wheels. Then I covered the car (or the positive space) with a low tack masking film or frisket and cut out its shape with a razor point knife. The surrounding area (or negative space) was air brushed with a darker brown to give an even background and to contrast with the wash effect on the metal car body.

Once matted and framed, this ink drawing with some color added makes a very handsome wall decoration.

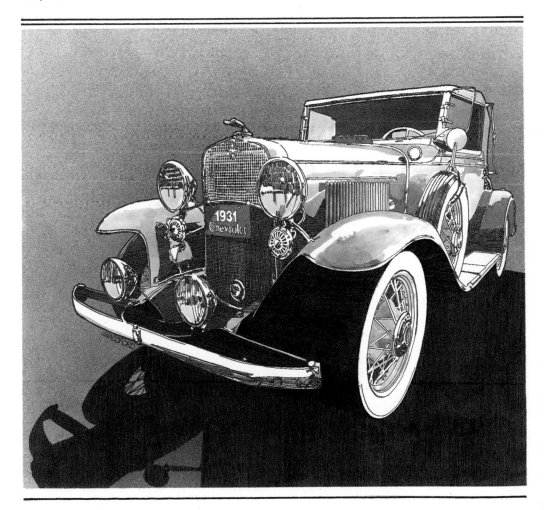

USING COLORED INK

To add color to pen and ink drawings, I use water colors or concentrated dyes. There are several brand names to choose from but each manufacturer offers a range of colors in small bottles. I apply the ink with a brush or an airbrush. I seldom use a pen to deliver color because I use a wash technique and need the brush to lay down ink mixed with water. I put a small amount of ink in a plastic mixing tray and combine water with ink before applying color to the drawing. I do a complete pencil detail of the subject, add the color with brush, then add detail and outline with the black ink of the technical pen. Study the drawing of the airplane and see how I've "washed" 100% color into lighter versions by adding water. I've also laid one color over another to mix hues and get light or dark effects. The upper blue background was airbrushed with some red overspray and

ULTRAMARINE BLUE: SKY BACKGROUND USING AIRBRUSH TECHNIQUE GOING FROM FULL OR DARK SPRAY TO LIGHT SPRAY. THE WHITE SPECKS COME FROM A FLICKED TOOTHBRUSH.

SCARLET RED: HORIZON LINE AIRBRUSHED FROM HEAVY CONCENTRATION TO LIGHT SPRAY TO VARY INTENSITY.

NORWAY BLUE: TREE LINE AND DARK SHADOW AREAS. 100% DARK BLUE MIXED WITH DARK GRAY TO GIVE THE DARKEST PART OF THE SHADOWS.

MEDIUM ORANGE: ACCENT COLOR. PROPELLER TIPS, PROPELLER WARNING LINE AND NAME LETTERING. STRAIGHT COLOR WITH LITTLE WASH IN THE SMALL ACCENT AREAS.

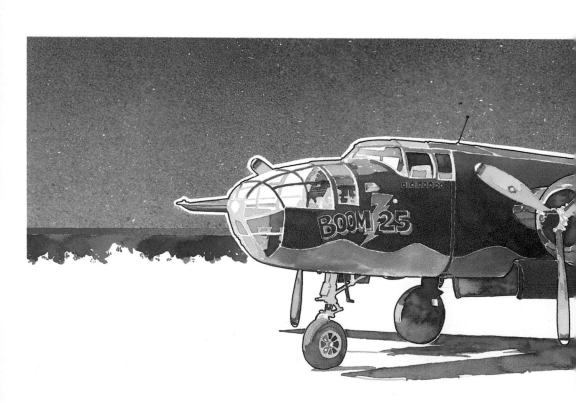

white splatter to form "stars." The lower blue "treeline" was done with a brush. The color samples indicate wash effects and mixing techniques.

LIGHT BROWN: UNDER-CARRIAGE AND UNDER WINGS. THE GROUND REFLECTION VARIES THE LIGHTS AND DARKS.

OLIVE GREEN MIXED INTO **LIGHT BROWN:** UPPER BODY PAINT WITH A LOT OF REFLECTION.

LIGHT BROWN OVER **OLIVE GREEN:** TWO COLORS FORMING A DARKER THIRD COLOR OR HUE FOR BODY SIDES IN SHADOW.

DARK GRAY: SHADOWS ON THE PLANE AND ITS SHADOW ON THE GROUND. BLACK IS NOT USED FOR SHADOWS HERE AS THERE IS SOME REFLECTED LIGHT IN ALL DARK AREAS. DARK BLUE IS LAID INTO VERY DEEP SHADOWS TO DARKEN AND ADD INTEREST.

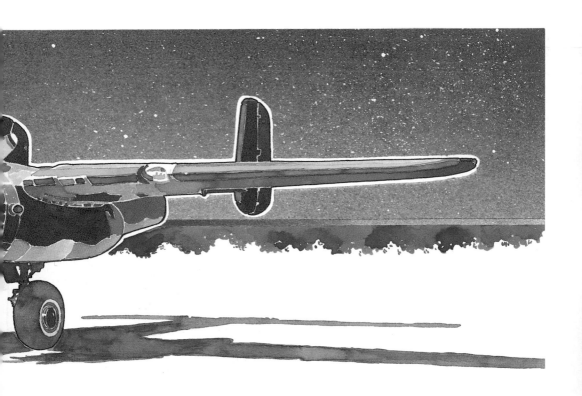

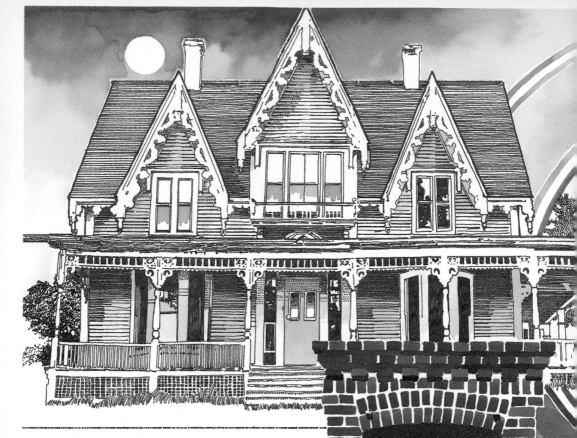

COMBINATION OF SUBJECTS AND DESIGN

A drawing can be very interesting. Several drawings together can be a challenge. It is the montage that not only tests drawing ability, but an overall design sense as well. How to stop and start, what to use where, size and proportion are all part of the problem. There will, for me, be a lot of preliminary sketches. I'll use graph paper or mechanical drawing tools to organize the shapes and parts. If there will be color, what colors at what strength in which position? There will be a lot of unseen work for any montage or combination.

There will also be 1½ renderings. No matter how well I plan, I get halfway through the final and find I have "learned" some new things.

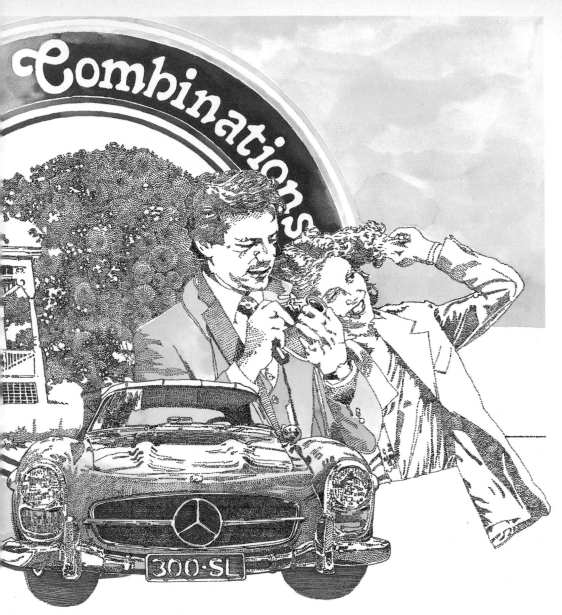

Combination drawings usually portray many ideas or concepts. No one item will tell the story, so you want to draw all the major ideas into one presentation. In this montage, the brick window gets a lot of importance because of its size, placement and color. The house has a lot of detail, so it has no problem getting attention. The car and people hold their end of the work because of dynamics and automation. But the tree, a lot of dots and work, is merely background material. So, how much effort do you give the background or lesser objects? There are many answers to that question, but here, the background tree and graphic circle tie the major elements together. Therefore, the glue that holds the drawing together gets enough work to make it a strong binding element, but not so fancy that it competes with the top billing.

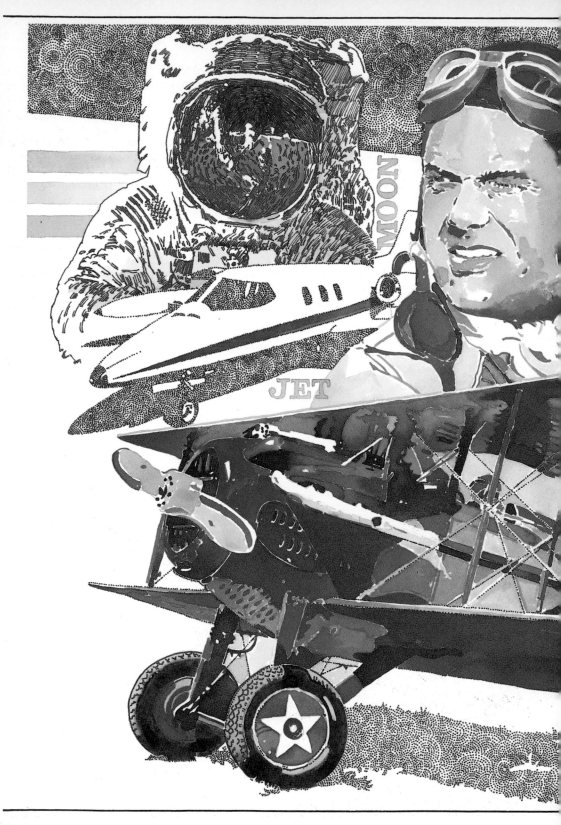

COVER ART

The cover art incorporates all the ideas presented in this book: line, texture and color. It is a combination of drawings to represent a concept. And, it is a collection of techniques to form a pleasing design. You can see that an artist must be organized to juggle all of these factors to produce a finished illustration. A good result has a genealogy of many thumbnail sketches.

The theme here is a short history of aviation progress. The colorful World War I plane is the major element because of its shape and complexity. Its pilot is the major human element. The WWII aircraft carrier (detailed on pages 56 and 57) is really just detail background or texture. The contemporary business jet merely separates the pilot from the future. The reasons for size and shape are artistic, not historical. Art isn't changing history (these things really existed in these shapes), it's just designing its presentation.

While we're looking at this colored reproduction, let me remind you that the printing process does not always reproduce colors as painted on the original art. What the film "sees" and how the printing presses are "tweeked" sometimes is different than what your eye would see if you had the original at hand. So, if you are practicing someone's example and your orange is a bit different, go with what your eye says looks best.

SPAD VII

DESIGN VARIATIONS

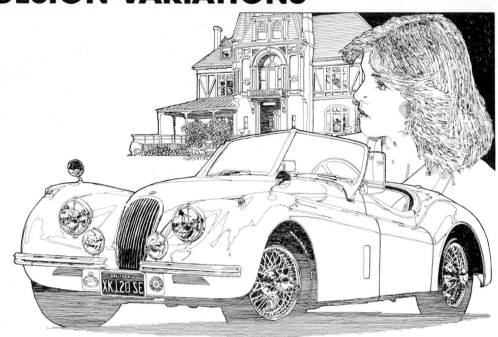

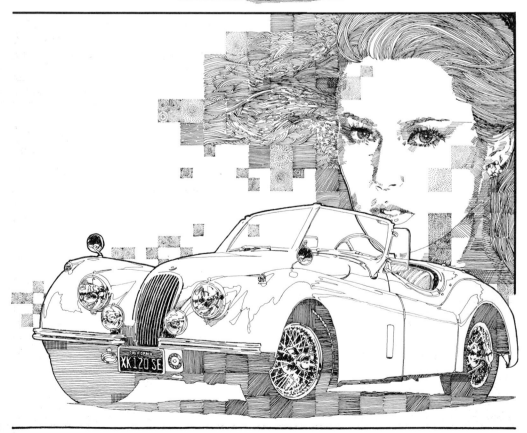

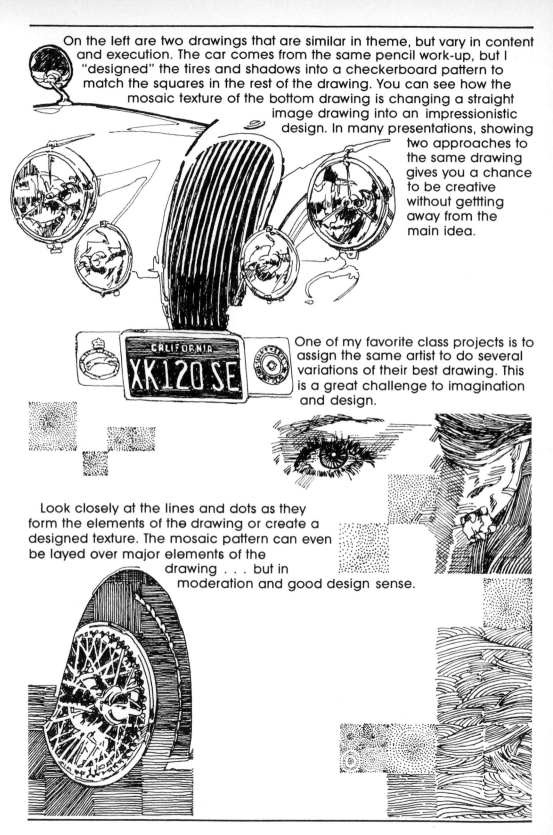

On the left are two drawings that are similar in theme, but vary in content and execution. The car comes from the same pencil work-up, but I "designed" the tires and shadows into a checkerboard pattern to match the squares in the rest of the drawing. You can see how the mosaic texture of the bottom drawing is changing a straight image drawing into an impressionistic design. In many presentations, showing two approaches to the same drawing gives you a chance to be creative without gettting away from the main idea.

CALIFORNIA
XK120SE

One of my favorite class projects is to assign the same artist to do several variations of their best drawing. This is a great challenge to imagination and design.

Look closely at the lines and dots as they form the elements of the drawing or create a designed texture. The mosaic pattern can even be layed over major elements of the drawing . . . but in moderation and good design sense.

FIGURE STUDY

Beginning artists always draw people at rest. But as you advance, you want to show animation and movement even in a static drawing. Making lines that capture the dancer's grace or the athlete's pain is the test of your abilities. This series of Number Six looks at the steps and studies I went through to portray a quarterback at work.

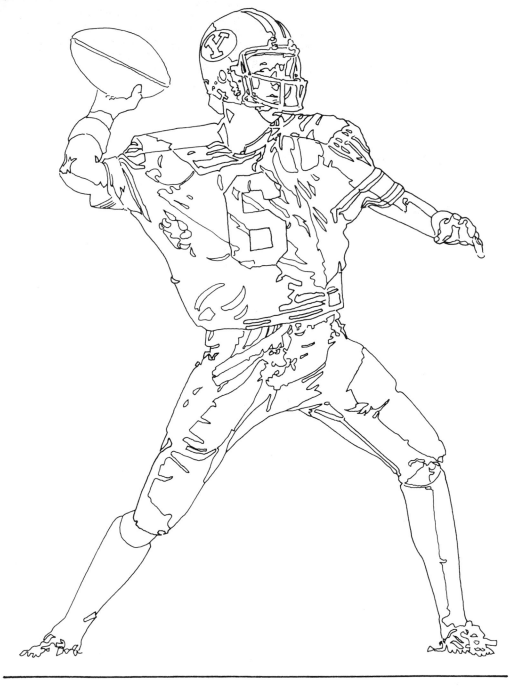

The line drawing outlines all the shadows that will form the shapes of pads and clothing. The arms and legs are normal human form, but the chest is enlarged to accommodate the shoulder gear and flac jacket. The arms and legs must be at once in balance and in stress. The face, though hidden by the face protector, must show concentration and intent.

Once the line skeleton is finished, the pencil "meat" can be placed. The lights, mediums and darks now define the dimensions, not just the surfaces.

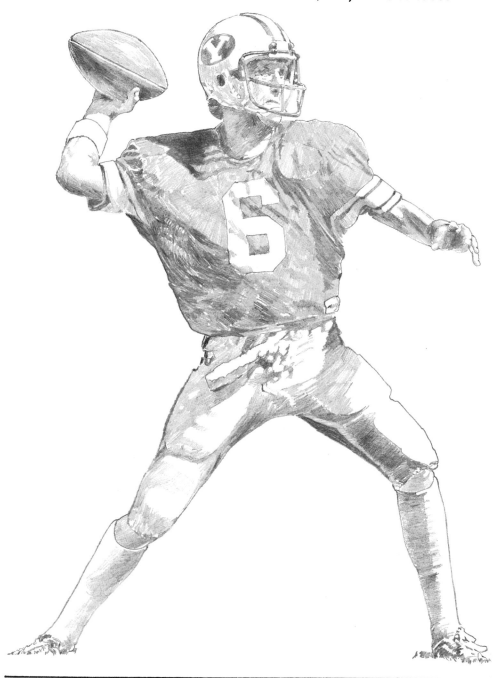

The close-up below is a study of a face we cannot see very well. There is no emotion in a helmet, so with a slight set of mouth and hint of eye, the resolution of this player is portrayed.

The final colored ink rendering incorporated all that I've "learned" about this football player. The Greeks weren't the only athletic people, so we can borrow from their heroic poses.

The graphic background is a desire for pushing the figure forward, as well as decorating the space.

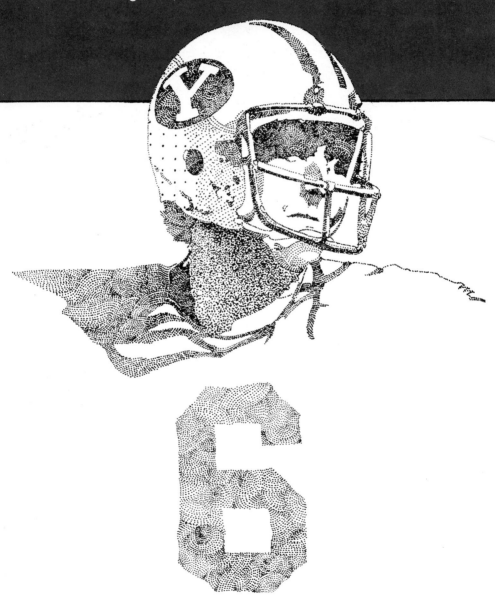

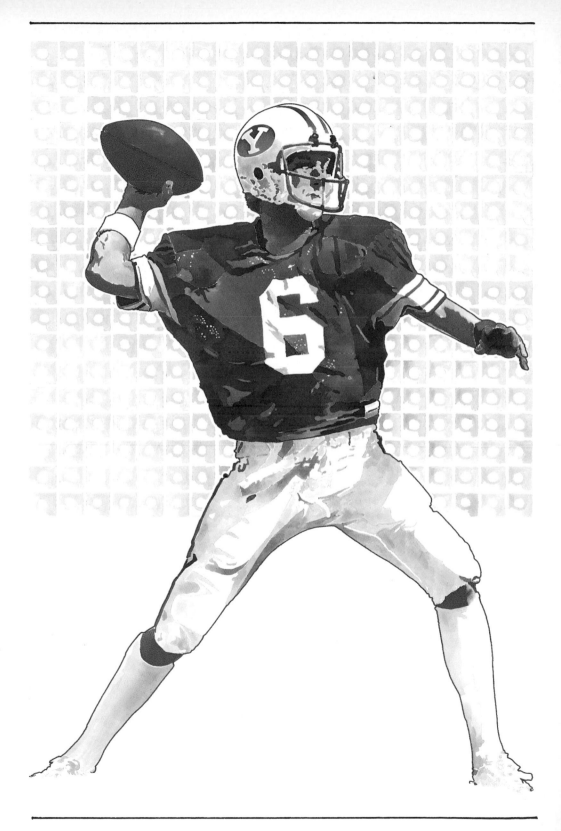

A SERIES OF THE SAME FACE

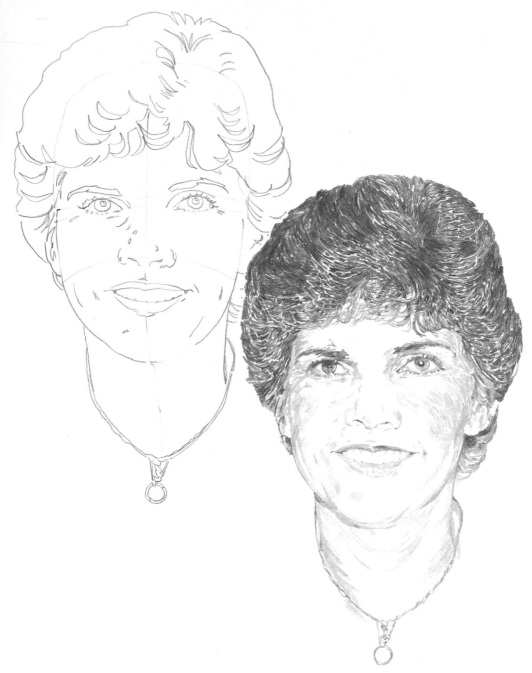

These different studies of the same face show the relationships of medium. What you do in pencil can be used in ink or colored pencil or colored ink. Each drawing has unique forms of shading or shaping, but the drawing style translates from one rendering to the next. For example, look at the treatment of the hair. What is finalized in the pencil is used directly in the colored pencil. Eventhough

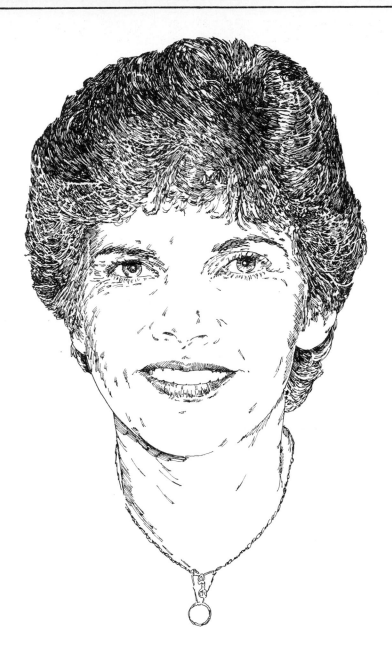

there are now color choices, the lights and darks form the hair and its texture. The ink drawing concentrates lines in the dark and widens spaces to form highlights. The colored ink lets browns and yellows do the work of blacks and whites. So, pick a part of the face and see how it is portrayed in each example. These comparisons should broaden your abilities.

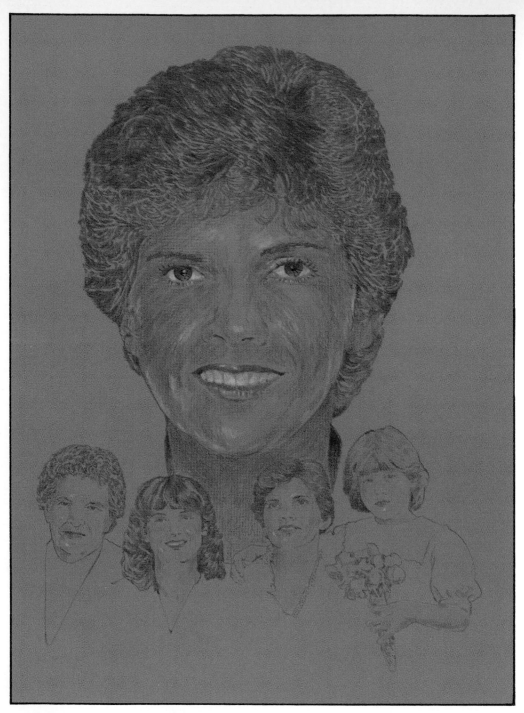

The colored pencil offers a bit more design in the additional heads and their placement. I have used design procedures in the hair and shadows, but have let the particular face determine what went where (although I have made some choices as to what lines and wrinkles to leave in or take out . . . always do the subject a favor!)

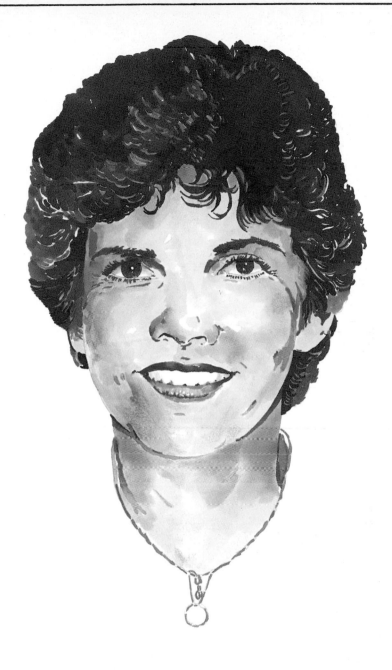

The final colored rendering of this series has the warmth and glow of the sub-
ject. I find the corners of the eyes and mouth to be accent points to the emotion
of the face. Notice, too, how the neck chain forms the lower end of the
drawing.

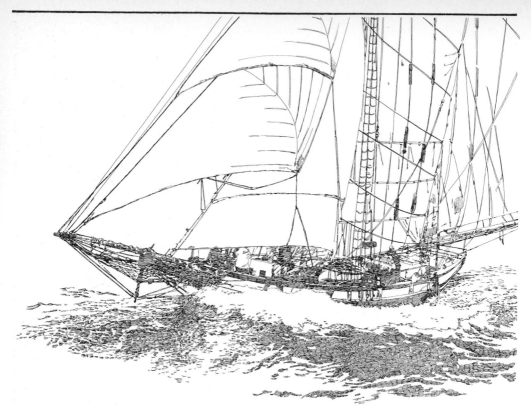

DRAWING WATER

This exercise is not bringing liquid out of a well . . . it is using black lines to represent foaming, moving water. The sea is not flat. Nor is it one color. To capture moving water, you have to study it. Where do the white bubbles come from? How does one anticipate reflections? Water is hard to draw!

I've not mastered it yet, but I find photographs of water in motion helpful in studying where the lights and darks form. I have a whole collection of pictures of streams and waves and wakes just to help me form a starting point in representing

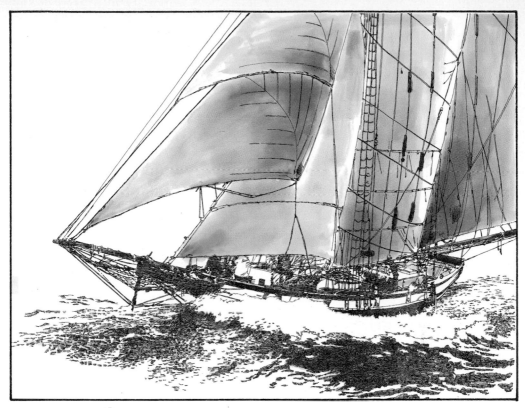

water. I do find the white water of the bow and side spray of a boat helpful in separating ship from sea. However, I oft times have to resort to guessing when active water is part of my illustration. I now appreciate those ship renderings that rest on a straight horizontal line to indicate calm, smooth water. Art can be so simple! And I used to draw all my people with their hands in their pockets, too.

The right hand drawing is a photocopy of the left with some color washed into the sails to shape what otherwise looks flat. The drawing below is at 100% ink line size to show formation of detail with short strokes bunched in threes and fours.

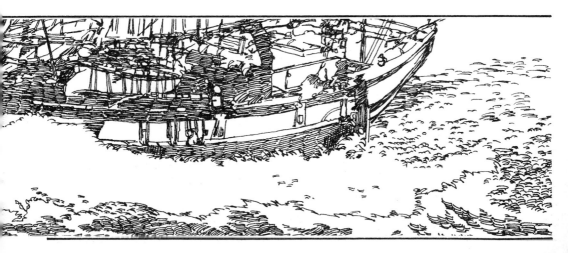

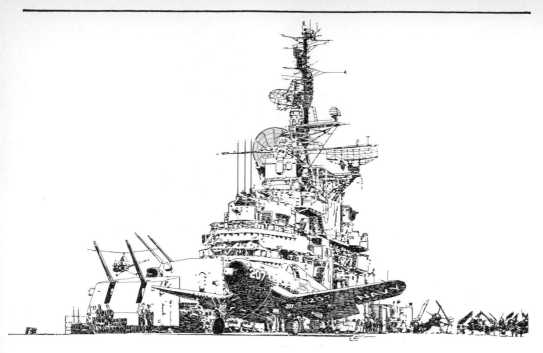

THE OLD PHOTOGRAPH
AS A MODEL

For many of the drawings I do, I use my library for resource material. In this case, I have an old family album from the Korean War days published by a navy

Some of my favorite models are the people in very old photographs. Because they had to remain still for many seconds in order not to blur the image, their expressions and gestures are very different from contemporary subjects. There's something about all those guys who hung out around old stream engines that I find fascinating. And they don't charge model fees!

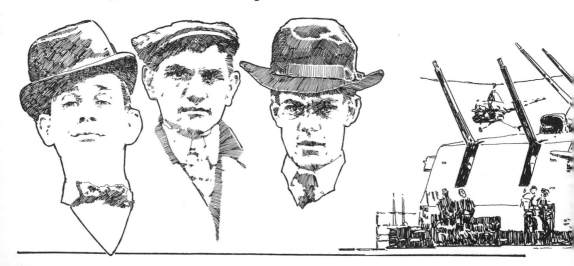

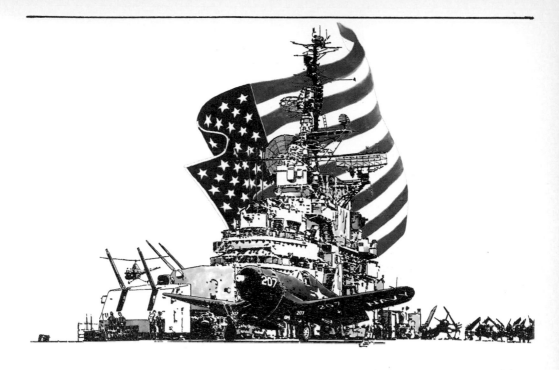

aircraft carrier. I love old planes and ships, so this is a natural subject for me. The photos supply the details of the things on the flight deck. The artist must build the forms on which to hang the details. And be careful in the shadows. Old photos tend to have solid black shadows, but the artist can add some specks or pull some light to give indications and interest to those dark areas. I'd rather not use a solid black unless there's absolutely no chance for some reflection.

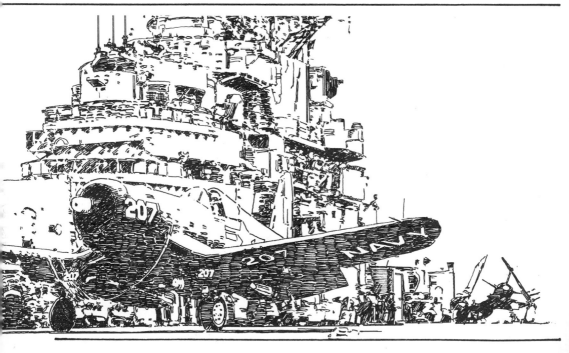

MISCELLANEOUS

Here's a parting look at some subjects I really enjoyed drawing, but have no specific category in which to present them. All of these ink drawings began as a pencil thumbnail sketch. Then the sketch became a detailed outline on which ink lines or dots could be laid. Once the rendering was completed, any visible pencil was erased and the piece was done. Look through these remaining illustrations and see if you can pick out any combinations of lines or dots you'd like to use in your own drawings.

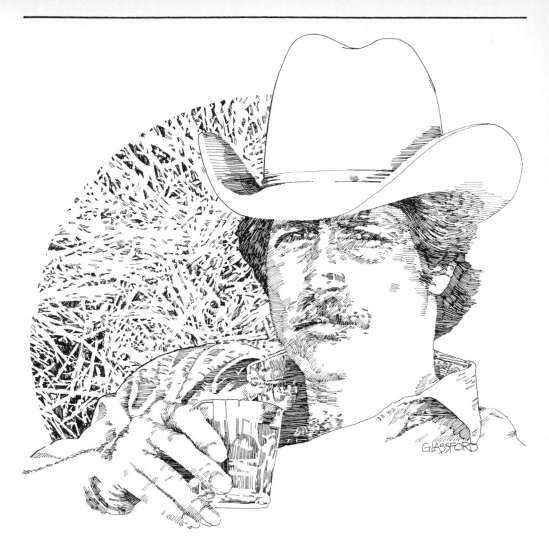

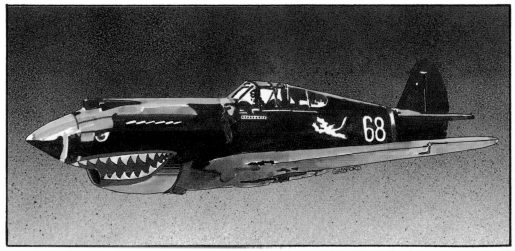

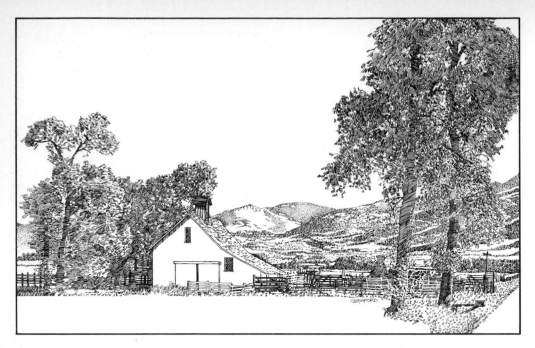

The old farm in the center of Utah. There are a hundred places where the valley meets the creeks coming out of the foothills. Here the farms bunch around the water supply and high pasture access. A lot of people spent a lot of time and effort to give artists some great places to sit and draw.

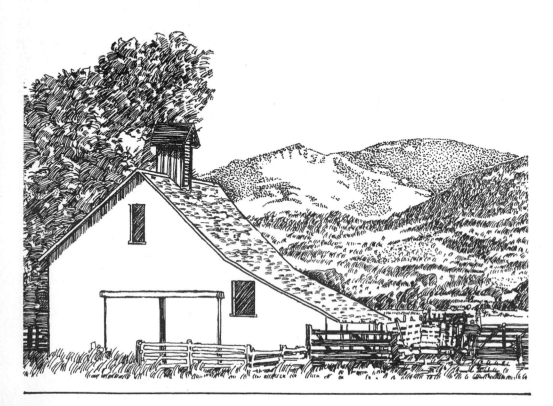

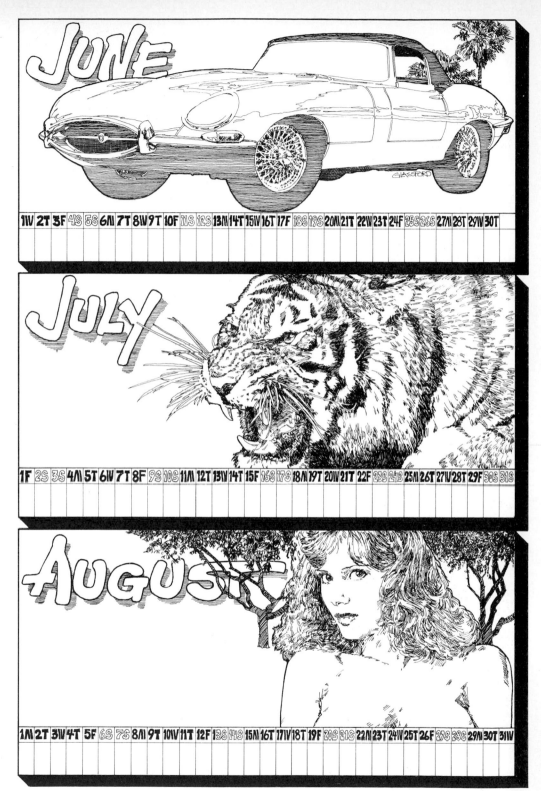

Line art for a calendar featuring the theme: SLEEK.

WHAT TO DRAW?

It's really silly to be a practicing artist sitting down to draw and nothing happens. The mind understands the direction, but the imagination can't form an image. Or, you're going through the motions, but nothing good is taking shape. Is it burn-out or fatigue or lack of concentration? Whatever it is, it happens to us all. How to get over it, or around it, or through it is a trick we must all learn. For me, there are two ways out of the doldrums. One is to doodle. Just start in the middle of the page drawing little boxes and circles. The design expands and becomes more complicated. Soon, I am so engrossed in the doodle that I forget the original problem and work hard to form this new design. There is no right or wrong with a doodle, only lots of ink forming a lot of anything. Some of my doodles have become so large and complicated and colorful, that I put a mat on them and get large complements for my very original works of art. A few of them hang around my house or office to remind me of the rejuvenating process. And it always works. As soon as I can get my mind off all the fun I'm having with the doodle, I can get to the original challenge with renewed spirits. Sometimes, for variety, I'll substitute a jigsaw puzzle for the doodle. There's real value in engaging your mind in some other fast forward gear.

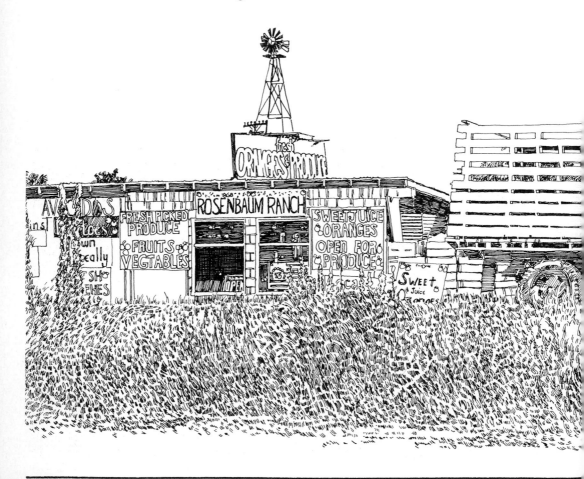

My second doldrum buster is to stop the project that has me stymied, and work on something I really enjoy drawing. Tops on the list for me are cars or my kids. I keep these "anti-frustration" drawings together and over time, you can see the evolution of automotive history and the growth of my family. But, it works to fuel my imagination and motivation for some must-do assignment.

And, the last point of this segment, is to edit and keep your good doodles and fun drawings. I can't tell you how many times I've gone into my ramblings to find the start of some great art project. The mind likes to store ahead for times of drought, so look to the storage tank.

The drawing below is from a picture I took long ago of a roadside produce stand where my family bought oranges. The place was surrounded by trees and gardens producing the daily sales. The spot now is a hundred houses, so I'm preserving some California history.

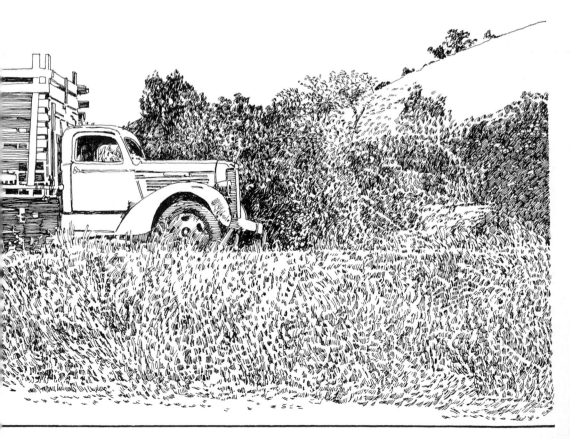

THE END OF THE LINE

Well, there's a look at how I deal with pen and ink drawing. The lines, the dots, the textures, the designs and the colors are all part of my ongoing learning process. Let me encourage you to try some of my suggestions. Test the pens, the inks, the papers and the colors. Keep track of the things that work or feel comfortable. Use them like new words until you can freely speak them in sentences. Art is an activity in which the more you learn outweighs what you know. There are no degrees in art, only milestones. Thanks for spending the time . . . it's done me a lot of good to get ready for you.

CARL GLASSFORD

Oh, by the way, do you know what one question is asked of an artist more than any other question? That's right, "How long did it take you to draw that?" Sometimes I answer with my age. Sometimes I take the square inches and divide by four for the number of hours. Now, however, with a few gray hairs and some years to equal wisdom, I answer, "It took as long as it took." I hope, whatever your reply, you answer with a smile and not a frown.